The Later Works of J. M. W. TURNER

by Martin Butlin

TATE GALLERY Published by Order of the Trustees 1978

NOTE

The Turner collection at the Tate Gallery
normally occupies three galleries with an
additional gallery devoted to watercolours,
mainly selected from those in the Turner Bequest
now in the care of the British Museum Print Room.
As the selection is changed from time to time
references are not to individual examples but to
the Roman numerals under which groups of
associated works have been catalogued, for
example 'T.B. CLXXXI'. The Tate Gallery catalogue
numbers of the works reproduced are given at the
end of each caption and in the list of plates. In
addition to works in the Tate Gallery's own
collection mention is made of some in other public
collections particularly the National Gallery
with which oil paintings from the Turner
Bequest are sometimes exchanged.

A companion booklet by Mary Chamot on
Turner's early paintings in the Tate Gallery is
also available.

A complete catalogue of *The Paintings of J. M. W.
Turner* (including all those at the Tate Gallery) by
Martin Butlin and Evelyn Joll was published by
Yale University Press for the Paul Mellon Centre
for Studies in British Art and the Tate Gallery in
1977.

ISBN 0 900874 39 2
Copyright © 1965 Tate Gallery
Reprinted with minor revisions 1972, 1974 and 1978
Published by the Publications Department
The Tate Gallery, Millbank, London, SW1P 4RG
Printed in Great Britain by Raithby, Lawrence &
Company Limited at the De Montfort Press,
Leicester and London

LIST OF PLATES

The later works of J. M. W. Turner were dominated by light and colour to an extent unprecedented in the history of painting. This is not to say that they lack formal discipline—'Norham Castle' (plate 31), one of the most ethereal of all his oils, is nevertheless based on a compositional scheme derived from his early Poussinesque landscapes—but Turner's growing preoccupation with the forces of nature often led to new methods of composition, particularly the swirling, vortex-like designs of such works as 'Yacht approaching the Coast' (cover) and the 'Goethe's Theory' pictures (plate 29).

The qualities of light, colour and energy were implicit in Turner's earlier works but were not brought to fruition until his first visit to Italy in 1819. The overwhelming impact of the clear brilliant Italian light is shown in the watercolours done during this journey, on Lake Como, in Venice, and in and around Rome and Naples (T.B. CLXXXI, CLXXXVII and CLXXXIX). But the majority of the works he executed were pencil drawings and none was publicly exhibited in his lifetime. They served however as a repertoire of forms and as promptings to his exceptional visual memory, on the basis of which he could recall the excitement of his original encounter with the scene depicted.

Turner's first public demonstration of his Italian experiences was the over-ambitious 'Rome from the Vatican: Raffaelle, accompanied by La Fornarina, preparing his pictures for the decoration of the Loggia', his sole exhibit at the Royal Academy in 1820. This vast canvas is, it has been suggested, a tribute to Raphael as a universal artist, the anachronistic Claudian landscape and Bernini's 17th-century colonnades being introduced to stress Turner's own ambitions. 'Forum Romanum' (plate 3), often known as 'The Arch of Titus' and not exhibited until

six years later, gives a far more successful impression of the grandeur of Rome.

Meanwhile, in 'The Bay of Baiæ, with Apollo and the Sibyl' (plate 4), exhibited in 1823, Turner had painted the first of a series of wide panoramic landscapes that evoke the rich and sun-drenched Italian countryside. There is again a profusion of highly finished detail, including the wind-blown plume of smoke singled out by Ruskin as a special mark of Turner's landscapes. The composition, though clearly derived from Turner's earlier Claudian landscapes, is no longer based on recession by planes or diagonals but on curvilinear lines leading into depth and at the same time forming a flowing pattern on the surface of the picture. Later examples of this kind of landscape in the Tate Gallery are 'Childe Harold's Pilgrimage—Italy', exhibited in 1832, and 'Phryne going to the public bath as Venus—Demosthenes taunted by Æschines', exhibited in 1838.

Turner's second visit to Italy in 1828–9 produced less ambitious depictions of the Italian scene, such as 'Orvieto' (plate 9), actually painted and publicly exhibited in Rome. Here, as in 'The Loretto Necklace', painted on his return and exhibited at the Royal Academy in 1829, the foreground is occupied by a scene of everyday life instead of one taken from ancient history or mythology, and the composition, though based on the same general scheme as that of 'The Bay of Baiæ', is simpler and less contrived.

Throughout this decade Turner's oil sketches, like the watercolours done in Italy in 1819, were much less conventional than the finished oils. Typical in their free, liquid technique are the two panels showing George IV on his state visit to Edinburgh in 1822 (plate 1), to witness which Turner made a special journey, though no finished pictures were painted. The same fresh handling is found in the sketch for the large painting of 'The Battle of Trafalgar', commissioned by George IV in

1823 and now in the National Maritime Museum, Greenwich. In 1827, when staying with the architect John Nash at East Cowes Castle on the Isle of Wight, Turner painted nine small sketches including vivacious impressions of racing yachts (plate 7) and calm scenes of shipping at Cowes (plate 6) which were used for two pictures exhibited the following year (the finished painting of the latter subject is in the Victoria and Albert Museum). Also in this group are the exquisite 'Shipping off East Cowes Headland', the first of Turner's oils fully to recapture the delicacy of the Venetian watercolours of 1819, together with what seems to be his first study in oils of the sea and sky unrelieved by shipping or other incident, a rather tame forerunner of the stormy sea-pieces of the next decade.

A group of oil sketches of Italian subjects on coarse canvas dates from Turner's visit of 1828–9: one of them is for the large 'Ulysses deriding Polyphemus' exhibited in 1829 and now in the National Gallery. Like the Cowes sketches some of them were painted on a single large canvas, presumably for ease of transportation, but they are very different in style. Boldly painted in broad areas of blue, white and different shades of brown with occasional flecks of thick impasto, their subtleties of colouring are obtained by the juxtaposition of different tones rather than by delicate glazes. Some, like 'Lake Nemi' or 'Ariccia', are sunlit panoramic views, of the same general type as his other Italian landscapes but much bolder in treatment and without their literary associations. Others are marked by a new sombre and threatening mood, for instance 'Archway with Trees by the Sea' (plate 8). 'Rocky Bay with Figures' (plate 12), though similar to the former group in mood, is closer in technique to the Cowes sketches and may be the commencement of a finished picture paralleling the 'Ulysses deriding Polyphemus', particularly as its composition is based on two of the sketches on coarse canvas. The degree in which certain of Turner's oils are 'unfinished' pictures rather than sketches will be discussed later.

A group of smaller sketches on millboard was probably also painted on the 1828–9 visit. Most of them show what can definitely be identified as Italian scenes and seem to reflect Turner's first impressions of visual effects such as the sun setting over the Gulf of Naples. They may have been a substitute for the watercolour sketches of the earlier trip and were perhaps actually painted on the spot, a very rare practice for Turner, like the Thames sketches of twenty years before.

The George IV sketches (plate 1) and one of the Cowes group, 'Between Decks', reflect Turner's growing interest in figure-subjects during the 1820's, an interest also shown in the Watteauesque 'Boccaccio relating the Tale of the Birdcage', exhibited in 1828. This interest received a new impetus from the patronage of the art-loving third Earl of Egremont. Of the pictures that Turner had begun in Rome in 1828 the landscape 'Palestrina' had been intended for this patron, who however chose instead the study of a girl at a window, 'Jessica', illustrating *The Merchant of Venice*. This painting, exhibited in 1830, is still at Lord Egremont's home, Petworth, but the Tate Gallery's 'Pilate washing his Hands' (plate 13), exhibited the same year, and 'Shadrach, Meshach and Abednego in the Fiery Furnace' of two years later, show the same influence of Rembrandt in their composition, texture and dramatic contrasted lighting, allied with a use of colour which, though also derived from Rembrandt, is far more brilliant and produces a completely personal effect.

From about 1828, the year before his father's death, until 1837 when Lord Egremont himself died, Turner was a regular and privileged visitor at Petworth with his own studio there. The influence of the Petworth Van Dycks can be seen in the oil sketch of 'A Lady in Van Dyck Costume' and in the first of a pair of small paintings exhibited in 1831, 'Lord Percy under Attainder'. The companion 'Watteau Study by Fresnoy's Rules' combines a tribute to the French painter with a

demonstration of the observation in Charles du Fresnoy's *De arte graphica* on the effect of white in bringing a form forward in the picture-space or making it recede. Both works were painted on a pair of old cupboard doors and, the Percy family having direct family associations with Petworth, one suspects that the two pictures were painted there on the spur of the moment when Turner was without his usual canvases. Lord Egremont's purchase in 1827 of Hoppner's 'Sleeping Venus with Cupid' seems to have provoked Turner's nude study, 'Venus reclining'. Based on Titian's 'Venus of Urbino', it recalls Turner's earlier challenges to the Old Masters and was actually painted in Italy in 1828.

More important, Lord Egremont's patronage led to what are often regarded as Turner's finest landscapes, the oil sketches of Petworth Park, Chichester Canal, Brighton and a ship aground. These were done about 1828 in connection with the four finished oils of similar subjects now at Petworth, and their exceptionally long format reflects their original position, placed as it were like predella panels below the full-length seventeenth-century portraits in the panelled dining-room. The delicate colouring of 'The Chain Pier, Brighton' and 'A Ship aground' (plate 11) stems from the Cowes sketches of 1827, while the lozenge-shaped design of 'Petworth Park: Tillington Church in the Distance' (plate 10), with the almost palpable arch of its sunset sky, shows Turner's growing practice of making every part of a picture contribute equally to its composition instead of leaving the sky as a relatively passive foil to the landscape below.

A group of small gouaches on blue paper (T.B. CCXLIV) demonstrates how Turner's interests at Petworth were shared between landscape and interior scenes, the latter often reflecting the easy-going atmosphere of the company there. The gouaches of figures in conversation, at table, in front of the fire and so on were followed by a number of oils such as 'Music at Petworth' and 'Two Women and a Letter'

(plate 22), whose progressively bolder technique and thicker impasto suggest that they were painted well into the 1830's; like the gouaches they were never exhibited during Turner's lifetime. The series culminates in the extraordinary 'Interior at Petworth' (plate 2), a figure-subject without figures in which some elemental force of dissolution seems perhaps to echo the end of Turner's happy association with Petworth at the death of Lord Egremont in 1837. The restraint of the Petworth landscapes is replaced by violence, and form, colour and brush-strokes are all but completely liberated from the exigencies of natural appearances.

At the same time, in works not connected with Petworth, Turner had already moved away from the calm serenity that marks his landscapes of around 1830. This serenity is still apparent in 'Bridge of Sighs, Ducal Palace, and Custom House, Venice: Canaletti painting' (plate 15), one of the first two oils of Venetian subjects to be exhibited by Turner at the remarkably late date of 1833; Turner's renewed interest in Venice, where he had not been since 1819, led to a second visit later in 1833 and another in 1840. 'Van Tromp returning after the Battle of the Dogger Bank' (plate 14), exhibited the same year, continues the series of Dutch-inspired sea-pieces that had occupied Turner periodically since 1800, but he was already becoming more and more concerned with the destructive forces of nature for their own sake. In a series of unexhibited but roughly datable oil paintings of stormy seas Turner's technique became increasingly identified with his theme: these include 'Rough Sea with Wreckage' (plate 16) of the early 1830's, 'Waves breaking on a Lee Shore' (plate 18) of *circa* 1835, and 'Stormy Sea with Dolphins' (plate 19) of *circa* 1835–40. Even the earlier of these paintings, though at first sight more or less monochrome, often contain flecks of brilliant blue, pink, red and yellow which add an element of vibrancy to the colouring, while the last is an all but abstract expression

of light, colour and energy. This release from conventional modes of representation (first achieved by Turner, paradoxically enough for an artist whose primary interest was landscape, in 'Interior at Petworth') finally spread from Turner's stormy sea-pieces to the calmer waters of 'Yacht approaching the Coast' (cover) and 'Sun setting over a Lake', both probably painted in the later 1830's.

One particular incident that spurred Turner's interest in the elemental forces of nature, in this case fire and the dramatic effect of light against darkness, was the burning of the Houses of Parliament in 1834. He portrayed this event in watercolours (T.B. CCLXXXIII; CCCLXIV —373) and oils, but the same interest is found in a number of other works of the same period including the gouaches on brown paper of Venetian night scenes with rockets (T.B. CCCXVIII), painted in Venice in 1833 or, more likely, 1840, and, of his oils, 'A Fire at Sea' (plate 20) and possibly 'Stormy Sea with Blazing Wreck' (plate 17). With the exception of the two finished oils of the burning of Parliament none of these works was exhibited by Turner. Even the stormiest of the exhibited paintings continued to be more conventional, particularly in their degree of finish, until the 1840's.

Eye-witness accounts of Turner's procedure on the varnishing days preceding the openings of the annual Royal Academy and British Institution exhibitions show that from at least as early as 1830 the 'finish' of his exhibited pictures was frequently added at the very last moment. He is described as having arrived with a canvas no more than laid in with blue for sea or sky and yellow shading through orange into brown where there were to be trees or landscape, and as having then worked this up into a finished picture, presumably adding the details of his historical or mythological subject as he went. Many of Turner's most ravishingly delicate oils are just such lay-ins—'A Harbour with Town and Fortress' (plate 21), 'Sunrise: a Castle on a Bay' (plate 24), 'The

Ponte delle Torri, Spoleto', 'Sunrise: Shipping between Headlands' and 'Norham Castle' (plate 31)—and many others must lie beneath the finished works. Some of the more finished yet unexhibited paintings such as 'The Arch of Constantine, Rome' (plate 23) and 'Yacht approaching the Coast' (cover) show a stage beyond this but were presumably regarded as insufficiently finished to be shown to the public. The former, with the thick paint of the sky overlapping the thin flatly painted tree on the left, is very much a work in progress. These paintings almost certainly date from the later 1830's or 1840's. The Petworth landscapes of *circa* 1828 show that at that date Turner was still painting sketches on separate canvases, but examples of sketches which may have been intended to be themselves developed into finished pictures can also be dated to about 1830, the 'Rocky Bay with Figures' already mentioned (plate 12), 'The Thames from above Waterloo Bridge', 'Southern Landscape with an Aqueduct and Waterfall' (plate 5; almost certainly painted in Italy in 1828) and the National Gallery's 'Evening Star'.

In the 1840's the dichotomy between Turner's exhibited and unexhibited pictures, both in technique and adventurousness, tended to disappear. This can be seen by comparing the unexhibited 'Yacht approaching the Coast' (cover) with 'Snow Storm—Steam-Boat off a Harbour's Mouth making Signals' (plate 28), exhibited in 1842. The latter is as advanced in technique as the former and in both the dominating vortex-like composition is freely expressed. In these two pictures Turner was working on subjects that directly reflected his underlying interests and this became true of the majority even of his exhibited works. Venice became a constant theme and while 'Canaletti Painting' (plate 15), exhibited in 1833, had been given a historical association the majority of later examples were self-sufficient in their evocation of the beneficial power of the Italian sun, reflecting off stone

and water: for instance 'The Dogano, San Giorgio, Citella, from the Steps of the Europa' (plate 27), exhibited in 1842. Similarly with sea-pieces: historical subjects such as 'Van Tromp returning after the Battle of the Dogger Bank' (plate 14), exhibited in 1833, were supplemented by less specific contemporary subjects such as the whaling scenes taken from Beale's *Voyages* and exhibited in 1845 and 1846 (plate 30). The most outstanding examples of this growing identification of Turner's exhibited works with his deepest interests are the 'Snow Storm' already mentioned and 'Rain, Steam and Speed' at the National Gallery, which was exhibited in 1844; both set a man-made construction in the midst of the warring elements of nature.

A more personal impulse lay behind 'Peace—Burial at Sea' (plate 26), exhibited in 1842 as a tribute to the painter Sir David Wilkie who had died on the way home from Egypt the previous year. The angular black sails, echoed by the bird in the foreground, express Turner's grief at the death of his friend. The format of this work and a number of Turner's other exhibits between 1840 and 1846, which were painted on square canvases, the compositions sometimes circular or octagonal with the corners cut across, helped to concentrate the design and was particularly suited to the whirlpool-like compositions of such pictures as 'Shade and Darkness—the Evening of the Deluge' and its companion 'Light and Colour (Goethe's Theory)—the Morning after the Deluge— Moses writing the Book of Genesis' (plate 29), both exhibited in 1843. Here, though Turner had fallen back on the Bible for his ostensible, and somewhat ill-digested, subjects, his real interest was Goethe's theory of the contrasted emotional effects of the two halves of the 'colour circle' (a variant of the prismatic scale): the cold blues and purples of 'Shade and Darkness', colours seen by Goethe as being conducive to 'restless, susceptible, anxious impressions', are opposed to the warm reds and yellows of the other, more optimistic, picture. As in other works

of the 1840's the figures merge into the forms of the landscape, producing a new unity of design. Another example of a vortex-like composition in this format is 'The Angel standing in the Sun' (plate 32), exhibited in 1846, in which Turner transformed the text of *The Book of Revelation*, quoted in the Royal Academy catalogue, into an Apocalyptic vision of his own, that of the all-embracing, all-engulfing power of light. This picture marks, appropriately enough, the virtual end of Turner's achievement as a creative artist. In 1847 and 1849 (he showed nothing in 1848) he exhibited three works painted some forty years earlier, two of them refurbished: in 'The Hero of a Hundred Fights' exhibited in 1847 the newly painted glow of the furnace lies uneasily on the original dark-toned, dryly-painted interior. Finally, in 1850, he exhibited four new works on the theme of Dido and Æneas, stereotyped in composition, inharmonious in colour and turgid in handling. On 19 December 1851, having failed to show anything at that summer's Royal Academy, he died.

As the result of legal proceedings after his death that overruled the terms of his will the entire contents of Turner's studio, nearly 300 oil paintings and over 19,000 watercolours, drawings and sketchbook pages, entered the national collection. The oils are now divided between the National Gallery and the Tate; the other works are in the Department of Prints and Drawings at the British Museum. But this magnificent inheritance does not, it seems, reflect Turner's own intentions. Although he had preserved even the scrappiest of his sketches it was, when he revised his will in the late 1840's, solely 'my finished pictures' that he wished to be preserved by the National Gallery in a special Turner Gallery. In this, as in the importance he attached to giving subjects to his finished works, which were often exhibited with literary references or his own rather turgid verses (purporting to come from an epic *Fallacies of Hope*), his assessment of the nature of his achievement differs radically from today's. But, while the prizing above all of Turner's unexhibited oil

sketches and watercolours is probably justified, appreciation of his work can be deepened by taking his own intentions into account. For in a sense all Turner's pictures, even the sketches, are subject pictures. They are not impressions of landscape but visionary statements about landscape, about the forces of nature, whether life-giving or destructive, that underlie natural appearances. Thus Turner, although his work was based on phenomenal powers of observation, differed fundamentally from such artists as Constable and the Impressionists whose starting point was the everyday world of optical experience.

Turner's desire to express themes of significance was in part influenced by the artistic theory, current in his youth, of a hierarchy of the genres of painting in which mere landscape ranked well below history-painting, that is the depiction of improving religious, historical or mythological subjects. Turner's early emulation of Poussin's historical landscapes and the very scheme of his *Liber Studiorum*, a demonstration of the different categories of landscape, show his awareness of such distinctions. In addition he seems to have had a genuine desire to treat themes of human significance, but for a long time he was unable fully to realize his ambitions within the field, landscape painting, in which he found his natural mode of expression. This led to what now seems to be his rather misguided urge during much of his career to give specific historical or mythological subjects to his pictures, often literally superimposing them over exquisite sketches on the last few days before their exhibition. The inaccuracies found in the wording of many of his titles show that these subjects were not fundamental to his paintings. They should rather be seen as labels designed to justify, sometimes in a moral sense, his own more general intentions, which were often nothing more specific than the evocation of the emotion aroused by some ancient site or bygone incident. Even so his subject-pictures are usually more successful when allied to the depiction of some natural phenomenon, such as the storm

in 'Hannibal crossing the Alps', to take an example from his earlier works, or to some artistic problem, such as the emotive value of different colours in the 'Goethe's Theory' paintings (plate 29).

Turner's technique and the very way in which he portrayed nature developed in accord with his growing vision of its basic forces and with his gradual realization that these forces were of far greater significance for the human situation than the elevated subjects he had been adding to his landscape compositions. In his best works his technique became perfectly attuned to his real theme, whether in the delicate glazes, translucent colour and calm balanced design of 'Norham Castle' (plate 31) or in the thick energetic handling, strong vibrant colour and whirlpool-like composition of 'Yacht approaching the Coast' (cover). Turner's range had always been wide but in such late works as these the somewhat disparate interests of his earlier career were reconciled by an overriding unity of purpose.

FOR FURTHER READING:

Walter Thornbury *The Life of J. M. W. Turner, R.A.* 1862; 2nd edition 1877.
A. J. Finberg *Turner's Sketches and Drawings* 1910; reprinted with an introduction by Lawrence Gowing 1968.
A. J. Finberg *The Life of J. M. W. Turner, R.A.* 1939; 2nd edition 1961.
Martin Butlin *Turner Watercolours* 1962 and subsequent editions.
Michael Kitson *J. M. W. Turner* 1964.
Lawrence Gowing *Turner: Imagination and Reality* 1966.
Jack Lindsay *J. M. W. Turner, his Life and Work* 1966.
John Gage *Colour in Turner* 1969.
Graham Reynolds *Turner* 1969.
Luke Herrmann *Turner: Paintings, Watercolours, Prints and Drawings* 1975.

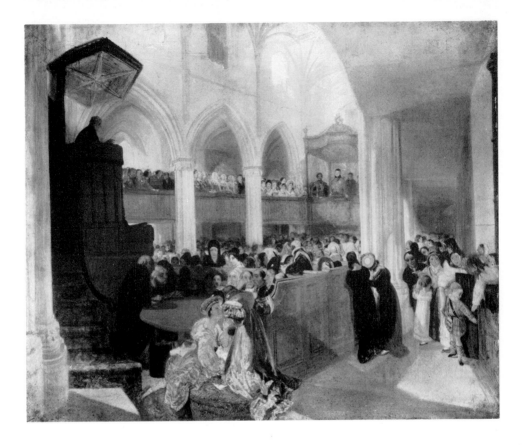

1 *George IV at St. Giles', Edinburgh.* 1822
Panel, 29 × 35¼ in. (2857)

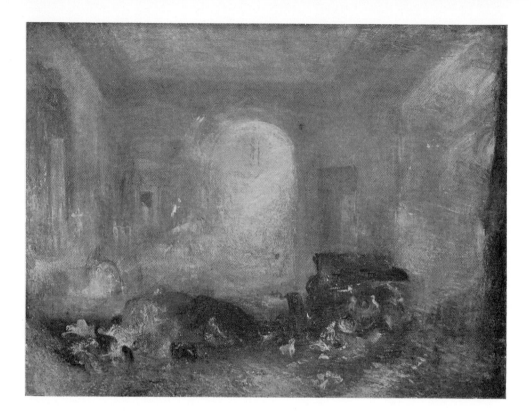

2 *Interior at Petworth. c.*1837
Canvas, $35\frac{3}{4} \times 48$ in. (1988)

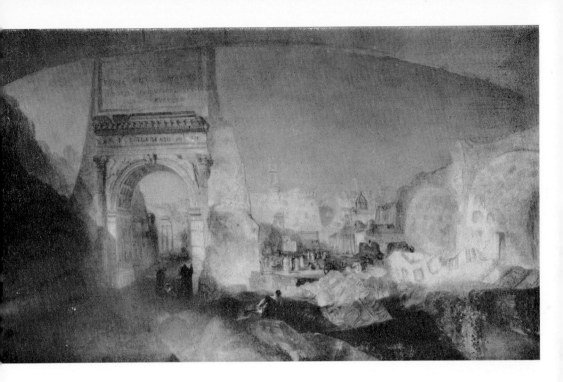

3 *Forum Romanum.* exh. 1826
Canvas, $57\frac{1}{2} \times 93\frac{1}{2}$ in. (504)

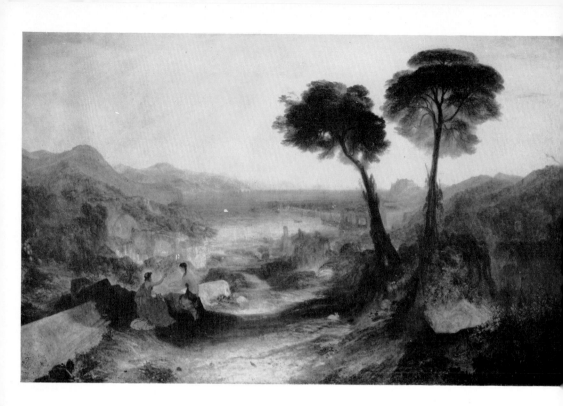

4 *The Bay of Baiæ, with Apollo and the Sibyl.*
exh. 1823
Canvas, $57\frac{1}{2} \times 93\frac{1}{2}$ in. (505)

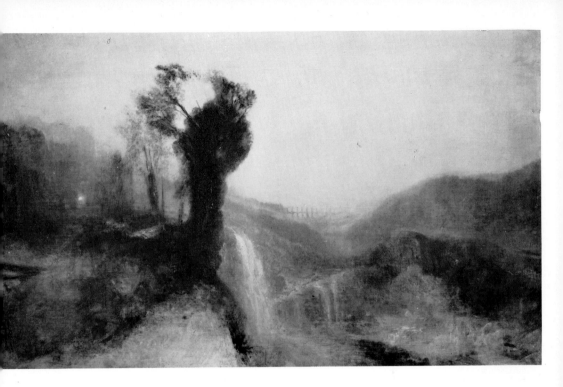

5 *Southern Landscape with Aqueduct and Waterfall.* ?1828
Canvas, $58\frac{3}{4} \times 98\frac{1}{2}$ in. (5506)

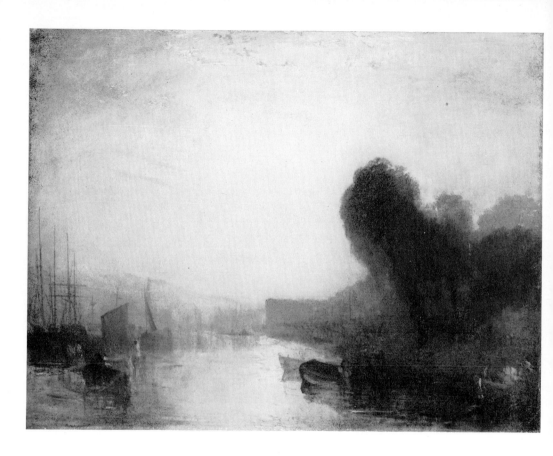

6 *Shipping at Cowes, No. 1.* 1827
Canvas, 18¼ × 24¼ in. (1998)

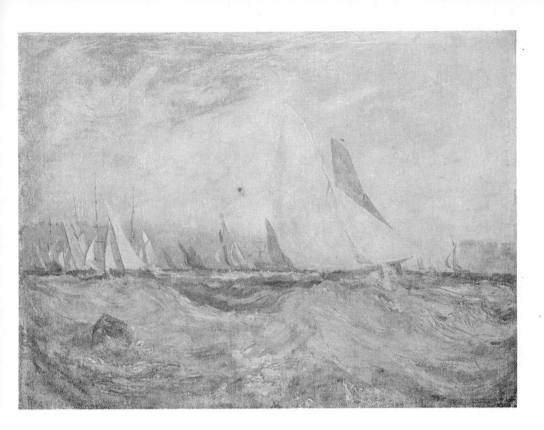

7 *Yacht Racing in the Solent, No. 2.* 1827
Canvas, 18 × 24 in. (1994)

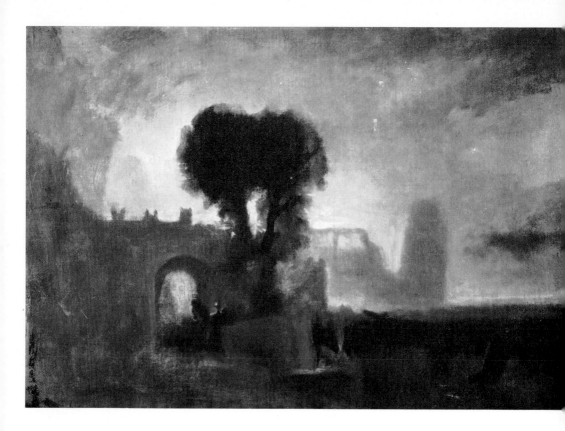

8 *Archway with Trees by the Sea.* 1828
Canvas, 23½ × 34½ in. (3381)

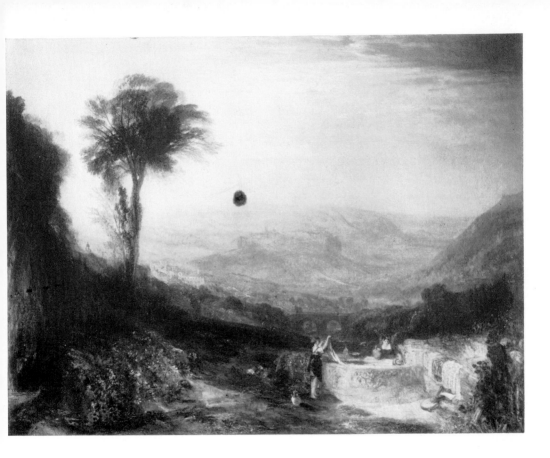

9 *Orvieto.* 1828
Canvas, 36 × 48 in. (511)

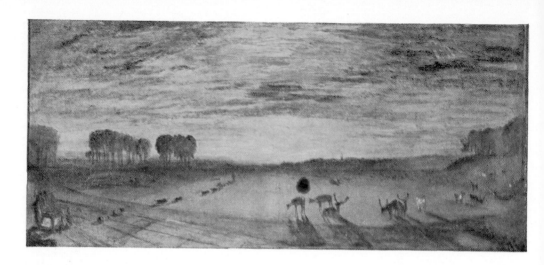

10 *Petworth Park, Tillington Church in the Distance. c.*1828
Canvas, $25\frac{1}{4} \times 58\frac{1}{4}$ in. (559)

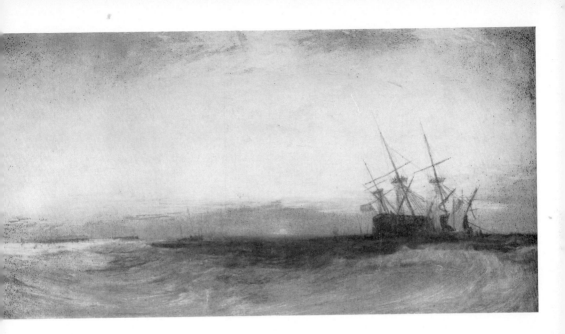

11 *A Ship aground. c.*1828
Canvas, $27\frac{1}{4} \times 53\frac{1}{4}$ in. (2065)

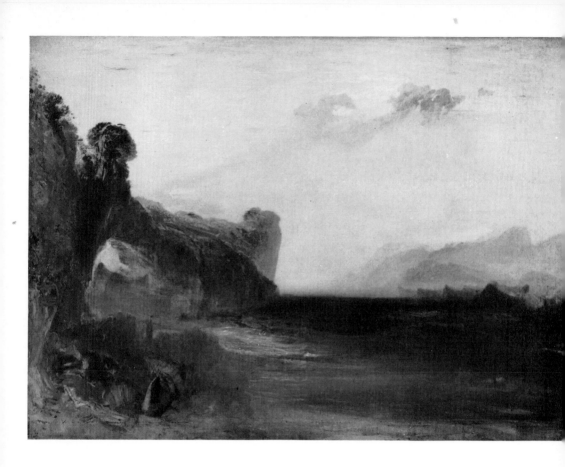

12 *Rocky Bay with Figures. c.*1828–30
Canvas, $35\frac{1}{2} \times 48\frac{1}{2}$ in. (1989)

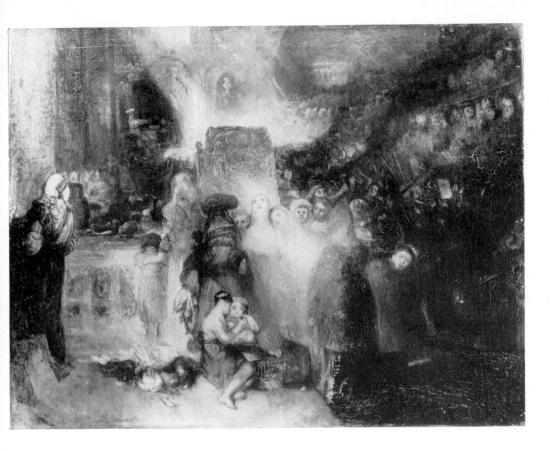

13 *Pilate washing his Hands.* exh. 1830
Canvas, 36 × 48 in. (510)

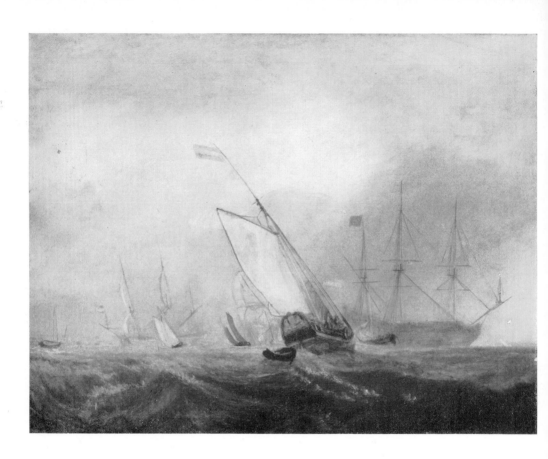

14 *Van Tromp returning after the Battle of the
Dogger Bank.* exh. 1833
Canvas, 36 × 48 in. (537)

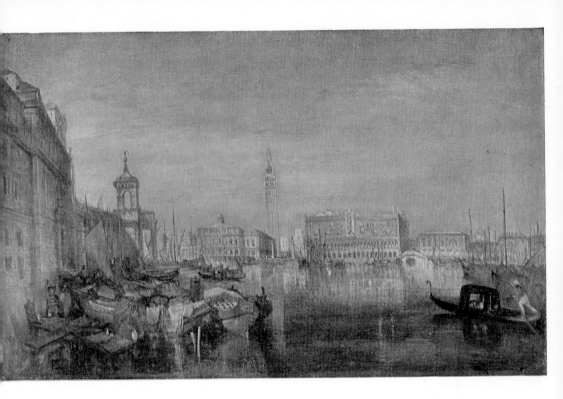

15 *Bridge of Sighs, Ducal Palace, and*
Custom House, Venice: Canaletti painting.
exh. 1833
Canvas, $20\frac{1}{4} \times 32\frac{1}{2}$ in. (370)

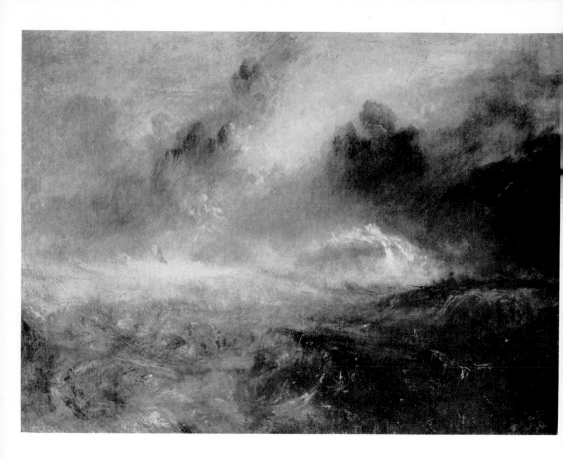

16 *Rough Sea with Wreckage. c.*1830–5
Canvas, 36 × 48½ in. (1980)

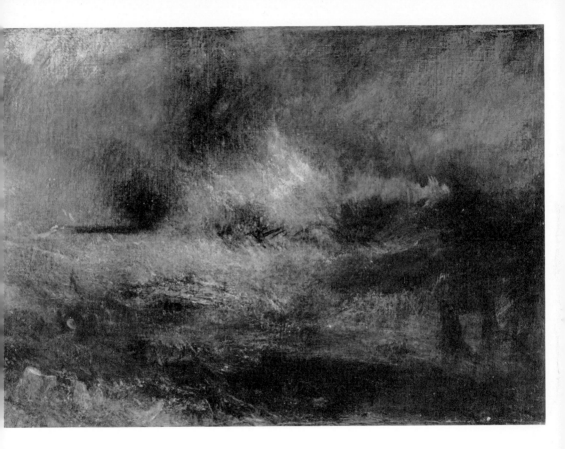

17 *Stormy Sea with Blazing Wreck. c.*1835–40
Canvas, 39¼ × 55¾ in. (4658)

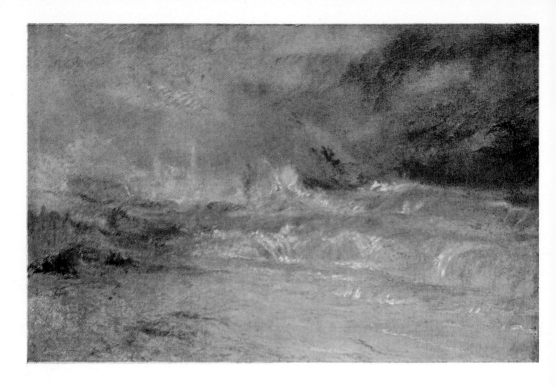

18 *Waves breaking on a Lee Shore. c.*1835
Canvas, 23 × 35 in. (2882)

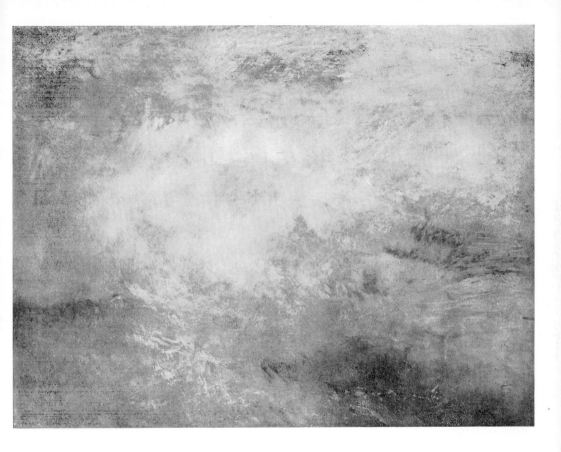

19 *Stormy Sea with Dolphins. c.*1835–40
Canvas, 36 × 48 in. (4664)

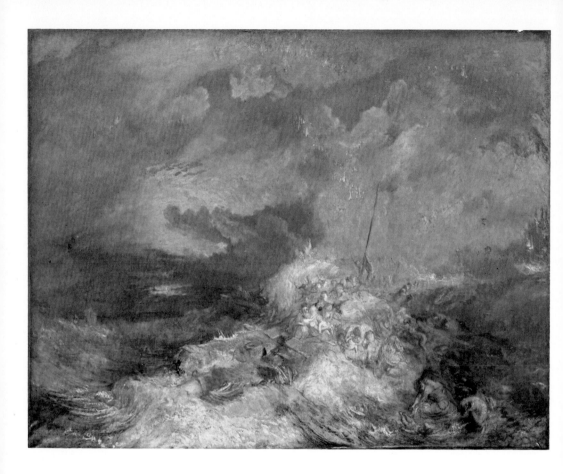

20 *A Fire at Sea.* c.1835
Canvas, $67\frac{1}{2} \times 86\frac{3}{4}$ in. (558)

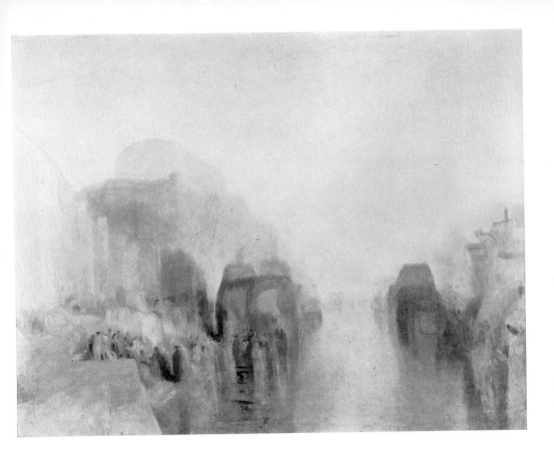

21 *A Harbour with Town and Fortress.*
*c.*1830
Canvas, 68 × 88 in. (5514)

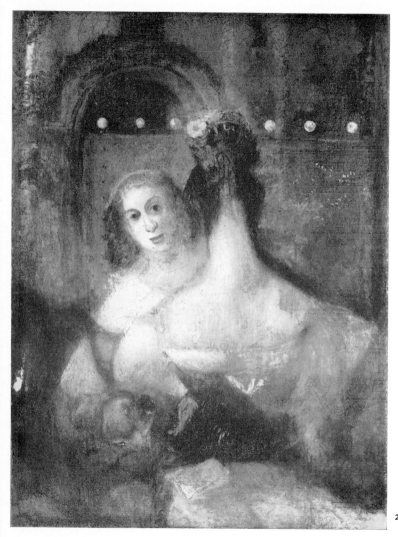

22 *Two Women and a Letter. c.*1835
Canvas, 48 × 36 in. (5501)

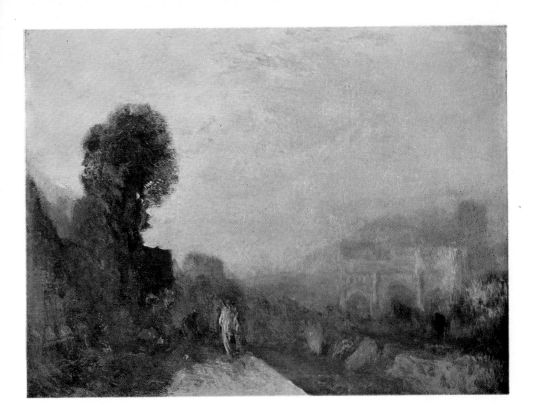

23 *The Arch of Constantine, Rome. c.*1835
Canvas, 36 × 48 in. (2066)

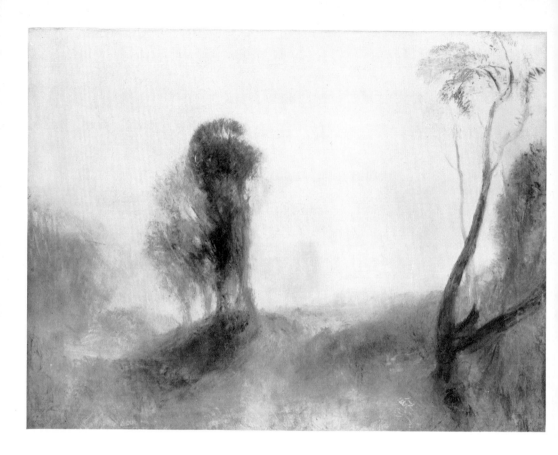

24 *Sunrise: a Castle on a Bay.* c.1835–45
Canvas, 36 × 48 in. (1985)

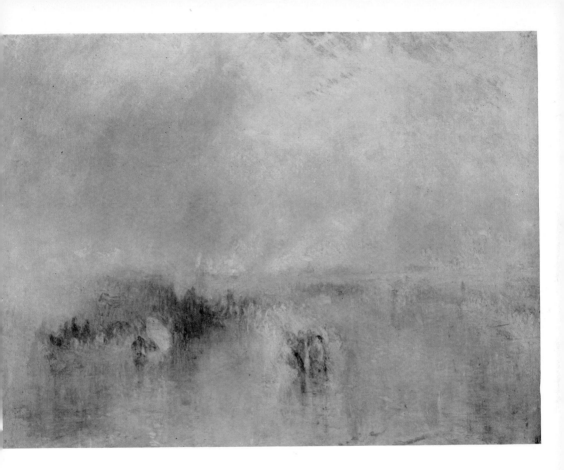

25 *Procession of Boats with Distant Smoke,*
 *Venice. c.*1845
 Canvas, $35\frac{1}{2} \times 47\frac{1}{2}$ in. (2068)

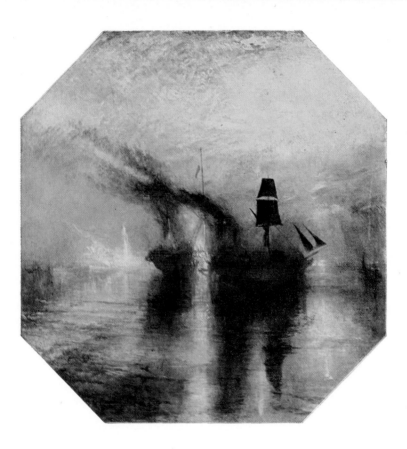

26 *Peace—Burial at Sea.* 1841–2
Canvas, $34\frac{3}{4} \times 34\frac{3}{4}$ in. (528)

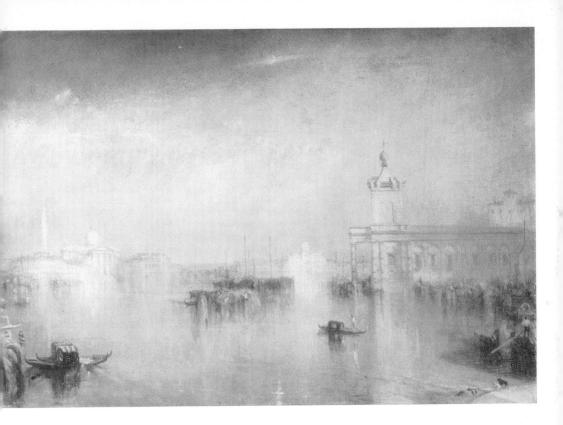

27 *The Dogana, San Giorgio, Citella, from the
Steps of the Europa.* exh. 1842
Canvas, 24¾ × 36½ in. (372)

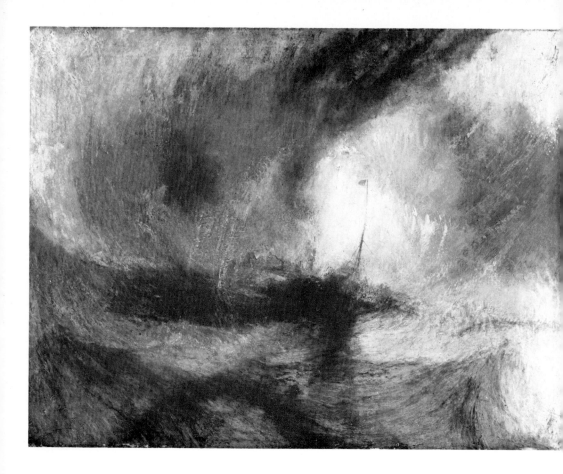

28 *Snow Storm: Steam-Boat off a
Harbour's Mouth.* exh. 1842
Canvas, 36 × 48 in. (530)

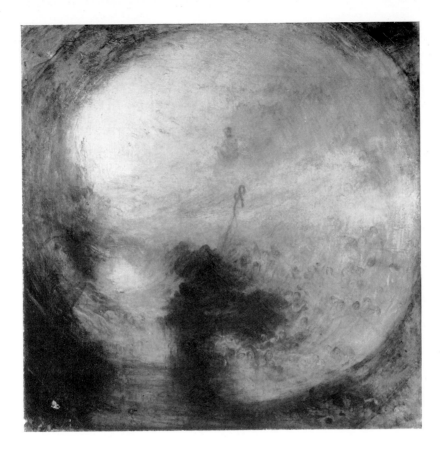

29 *Light and Colour (Goethe's Theory)—
The Morning after the Deluge—Moses
writing the Book of Genesis.* exh. 1843
Canvas, $30\frac{1}{2} \times 30\frac{1}{2}$ in. (532)

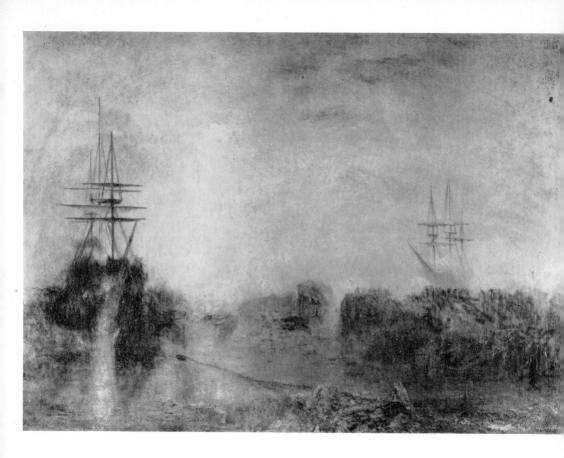

30 *Whalers (boiling blubber) entangled in Flaw Ice, endeavouring to extricate themselves.* exh. 1846
Canvas, 36 × 48 in. (547)

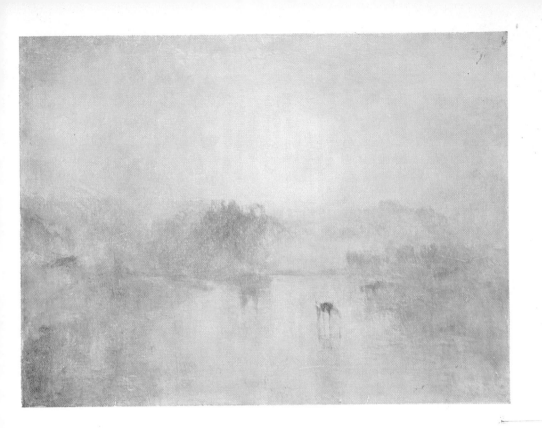

31 *Norham Castle, Sunrise. c.*1835–40
Canvas, 36 × 48 in. (1981)

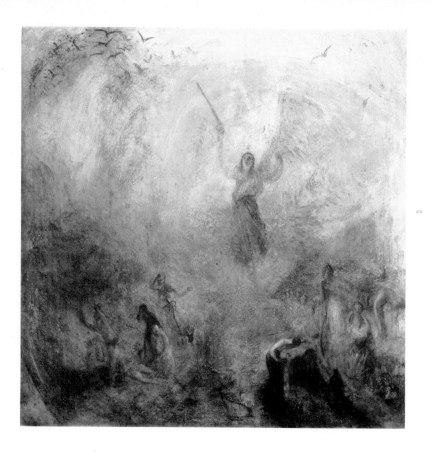

32 *The Angel standing in the Sun*. exh. 1846
Canvas, 30½ × 30½ in. (550)